Mind Soup

Mind Soup

Poetry by
Rafiles Dauthasi

Mind Soup Copyright © 2019 by Raphael Ihugo All rights reserved. No part of this publication may be reproduced, distributed, or transmitted in any form or by any means, including photocopying, recording, or other electronic or mechanical methods, without the prior written permission of the publisher, except in the case of brief quotations embodied in critical reviews and certain other noncommercial uses permitted by copyright law. For permission requests, write to the publisher, addressed "Attention: Permissions Coordinator," at the address below.

P.O. BOX 23, 00217 LIMURU

Kenyanvoice press, Nairobi
rafile1@yahoo.com

Rafiles Dauthasi

Content

Chapter one: love

Chapter two: my world

Chapter three: our world

Chapter four: other worlds

Chapter five: nature

Therapeutic

Mind Soup

We never know how high we are

Till we are called to rise;

Emily Dickinson

Rafiles Dauthasi

Chapter one: love

THE PERIROUS JOURNEY

I used to think that chapatis

Were humans best invention

Then I stumbled upon toast

Dipped in hot beef bones soup

Swallowed un-chewed in one swipe

Or chomped down in two chunks

But discovered then that was nothing

To mitura constructed from innards

And blood of slain beast

Then sold in wee hours besides kiosks

As on the barbequing smoke we choke

And on some financially lucky day

Feast upon feet of the slain beast

So boiled for soup then white as snow

This was a child's dream, heavenly it seem

And then one long rainy evening

In circumstances here and forevermore

Described as marvelous, miraculous

I stumbled upon real roasted meat

We are talking limbs of goats

Rafiles Dauthasi

Fat pieces fat dripping and so flesh

And I thought, heaven will never beat this

The roasted limbs were a miracle

To my mouth that upon such had never chanced

And I knew upon this I could feast forevermo

And henceforth satanic temptation would

Like a string willed martyr evangelical beat

Many years passed and unfit creatures died out

We gave it exotic names: they went extinct

And one beautiful Saturday the wedding happened

It was the village tycoon and very soon

I was feasting upon chicken thighs

Fish too was there, but which fool eat

Those wide eyes sea urchin, fruits of serpents

That day it was okay to feast on normal meat

And my elastic tummy stretched; a huge feat

My young mind was cruelly then exposed

To wondrous world beyond the egg toast

In our village we knew the seasonal fruits

Peer and plums and their sister as they came

But years later in a corporate banquet

Mind Soup

I would come upon watermelons and apples

Like ambrosia before, food just fit for kings

And now here strewn nude upon the oak table

Akin to those rumoured nights devil worship songs

Decades have gone by since that serious journey

Spirits of dead ancestors inimically in me cry

That they were the real martyr, heroes that came ere

And I bow down and give them much revere

For upon reading books and magazines and so hear

The delicious meat is poison for my legs

And will kill me before I exhausted my years

Milk is poison and only good to feed mammals

Fruits vitamins interfere with DNA,- crazy shit

Eggs are a short cut to the mercurial Hades

And if I don't stop gluttonously chewing that pork

The tree of my coffin will not have matured

Before death knell calls me to head to hell

As for wines and aged champagne and liquor

The men who know these things have cursed them

'Tis but only plain water, thoroughly boiled

That's good enough to sustain my vulnerable health

Rafiles Dauthasi

In this filthy and cursed Vale of tears… oh

Here comes a text from the apple of my eye

"Hey babes, what will we have for dinner?"

Her imagination

The colour of her dress

Was as white

As the full shameless moon

That stared at her

As if very soon

She would achieve her destiny.

A shape like a tear

Spread on a sheet of white paper

Was on the dress spangled

Upon the breast

The shape was pink

And on it a dark spot

The dark spot

Is what one saw

As if it entirely

Made the white dress.

Rafiles Dauthasi

The shameless white moon

Had been right for soon

She achieved her destiny

And cast her eyes yonder

At the butcher shop

Where she and her family

Forever bought meat

Three times a week

Excepting Fridays forever. Catholic.

She had arranged the hour

As the stealth shower

To ruin her sweet love

On the butcher.

She knew the butcher loved her.

She could read hints aright

Like any other female of her species.

No shop was opened

No lights were on

Darkness was black

Mind Soup

Like the spot on her dress

The wind was constantly

Lifting the dust

And flinging it upon her

And whispering impishly

"Noooh noooh nooooh! Waaaaay!"

But the girl laughed

At her foolish fancy

Wondering how the juicy looking love

Would taste like

"Very colourful mangoes are not sweet"

Was a truism everyone in the village

Knew to heart

But this was juicy-look love

Not a fruit.

Before she could knock

At the steel door

She distinctively heard

A muffled scream.

Her imagination yelled.

Rafiles Dauthasi

People said he slaughtered at night

Things not edible

The girl ran home

Her imagination strong

People said he slaughtered at night.

Ah, love

So I met this girl

And the first thing I noticed was her curls

Then she said: "hi" and her voice melted

My un-eatable by hyena bone

She had a way with words; her eyes like suns shone

Her smile swayed king's ways; her words siren sung

And yet I won her heart and soul, imagine.

Like in heaven when gods were awarding organs

And Homo sapiens chose the grey matter

As serpent chose, crazily, poison and mutable skin.

But so do hawks too change talons.

She said she might fall in love some day

Lucky me that day was the next day.

We can't have dirty sex before marriage

Which is crazy in this double sex act age

But true love will to you do that too

What did the burnt poet say?

"O My love is like a red red rose"

That's nothing but we also told each other so, imagine

Her parents are monstrous hideous creatures

And they are saying it loud, the greedy love killers

That the apple of their eye won't marry me a rascal

But I laugh loudly like shaolin temple masters;

They have no idea how crazily in love we are

They don't know staring at each eyes we never tire

And that our love was conceived and approved ere time.

So I met this girl

And the first thing I noticed was her curls

SLEEP WALKING

Promise me you will keep

Secrets I will spill when asleep

And when I sleep walk,

Wonder off to dark places

Hold my hand, keep me intact

And safely guide me back

To the safe place of light

Promise me you will keep

All inside secrets deep

Away from those who will

In their vacuous way thinks

That this gentleman is a creep

And I you I promise I will keep

All you say while in death sleep

Guide you when you walk asleep

Away from the dark places

Safely guide you back for keep

To a place that sweet light in seep

COPE WITH

Cope with love

Cope with what I have

Cope with past

That shaped this me now

Cope with pain

Cope with dreams

Threatened by drudgery

Of house cleaning

God's temple cleaning

Cope

Cope with weekend

Shortened

By what we took before it even started

Some crimes never get reported

So you never get arrested

Border walls never mounted

So you cross over and get deported

Semen sterile empty and void

So no kids ever got aborted

Living

It's about you I write

Every emotion stated

Was for you expressed

I hope to feel

Your breath on my neck

So I write it down

I described the feeling

Of death to die with you

THE KISS

Kiss me so I won't need wine

Kiss me even when we dine

Your kiss is a message to my soul

The depth to which only you go

And let the whole world watch

As we kiss our worries away

And us and ours we make happy

Kiss me when it's still young the day

Let Venus as he leave the day to us

Go with longing of soon returning

To watch us these love birds

Let our kiss love, seal our deal

A DREAM

Love at the very first sight was always my thing

Later with a princess I would live like a king

In splendid palace engraved all in gold

Flowers at every corner, birds beautifully singing

Love at the very first sight was what I got

He was vivacious funny and won wherever he got

Into fights with his peers, rivals and other romantics

His embrace was a garden or roses where I lay

Love at the very first sight his family and ours fell

Their children were beautiful like imps from hell

It was a match made in heaven like the angels that fell

JUST A KISS

One day I will kiss a girl

That day I will know why it is so sweet

So sweet, secretive and something else

It will maybe be under a tree

A tree patched with noisy bird's nest

I will kiss a girl under a crescent moon

Behind doleful darkness, starry night

Only stars shamelessly staring

Commenting and harshly judging

About my lack of skills

In the whole sensuous affair

But one day I will kiss a girl 4 sure

Brewing local love

We meant by the Mgharo river

Where once deube the ugly ogre

Called home and roamed

There was a small glove

That sprung from the remnants of deube

Where every month we danced

To keep deube from ever rising

And our children again start eating

She was the ogre with a bag

Every once a full moon

The spirit of the ogre took hold

Of the villager who had been bad

And that villager by the river would hung

And kids loitering would capture and eat

And after that completely forget the deed

Rafiles Dauthasi

It was by the Mgharo River

Where our love brew was made

Home to the spirits of deube the ugly ogre

LOVE LANGUAGE

Not able to continue life without her
It broke my heart, left me in sorrow

She fought to have the love continue
I fought to kill everything there and then

I can't see the brown earth soaking sweet rain
And not remember her face that I filled with pain

And when we are in the end called to account
For moments we ruined, joys we took out

I will stand judged and condemned
Un-defendable, heart wringed and dried

Of emotion, empathy and all that is beautiful
Emptied and on dancing desert cast yonder.

Of true love and Friendship we may say
Beautiful epithets but never really describe it.

Love

Love is a wonderful, glorious, sweet thing

It creates a new queen and dethrones a king

It washes our hearts of even the original sin

It swims into souls and leave them new clean.

Love is a joyous, sanguine gift

When we are in a deep pit it gives us a lift

When we wish to visit the stars up there

It doesn't wonder how that we dare.

Love is soft like a clean white dove

Love is innocent like a puppy asleep

Love is what the butterfly flitter to keep

Love is all that we all have.

She was like my mother

She was like my mother, beautiful

She was like the fruit tree, fruitful

She was like the white priest; accent wisdom

We lived forever all our lives

So long as the queen in the hive was living.

She was like my father draconian

She was like my brother tough to bullies

We lived next to the frog chocking swam

Whence for school project we took clay for models

She was like the rich neighbour girl; with mysterious cash

She was tattooed and wore dungarees

A mark then of teenage rebellion and class

She was like the mayor; charismatic

And in a way I am after her image

And the love we shares was in truth beautiful.

The sex was wild for one thing

And none seemed to mind the sweat

She was like Jane Austen;

Magical.

A HAPPY LINK

I love how she love me

I want her in my life she

Want me to be a part of

A parcel like a petal on

A now mature red flower

Soon dead but instead

It blooms and look! look

And feel how so beautiful

Under the black green tree

It is beautiful to breath

And when Dead and our

Last sharp sweet breath

We take them under trees

And sweet water we drink

As like the old sage we think

On what before us came

And how inextricably with it

We happily share a link

Mind Soup

Say a whisper
Say a whisper

To my shadow

I close my eyes

And imagine:

My shadow vibrate

To your soul

Where chords break

From all rots

And so swim

To my soul

I close my eyes

And breathe you

For time is

Warping wickedness

Binding you to my sins

Rafiles Dauthasi

In the side

By the river

I see your skull

Grinning sweetly

To my innocence

That's you and me

We drown in the sea

To rescue your skull

Which binds your soul

On the seabed

Nude creatures laugh

As they swim in sins

Laughing at us as we drown

To rescue your soul

Which holds our soul

Witchcraft

When my eyes are by yours entranced
My heart shivers as it races.

My heart is a rock thumping at my heart,
When our eyes on each other reflect.

When my hand feels your sensuous skin,
My heart ruptures in dolorous joy.

My heart is melted by its warmth,
When your larky voice whispers into my ear.

When we achieve equilibrium by sharing time and god,
My soul shamelessly sings in\of secret joys.

And it is a profound, golden moment
When your witchy touch electrify my body.

Rafiles Dauthasi

Caressing Demons

First you smile

Then you walk a mile

Then you feast on red thighs

Then you go to church-

A temple for you will do

Then you give birth

Or donate sperms

To a whore or a virgin

Both will act as vessels

For humans are torch bearers

And where are they taking the torch?

The question is:

Where did they get the torch?

But, be blind to those questions

Don't smother the demon

Don't even think about it

Let them sooth you to sleep

The yellow sun is the source of light

Mind Soup

The green moon is the source of dreams

They are the fathers and mothers

Of all your demons

Who is the father, who is the mother?

Mothers have always been popular with sons

The breast has a greenish, uneatable quality

And the son must love the mother

Don't slay a demon

Don't slay yourself

ALL DIED

It was her first time

The boy too said it was his first

She was so scared

He was so unprepared

Luckily the room was everything

They sat on the bed

Talking nonsense and nothing

Soon the hands held

So surreal, so humid

Rivers were flowing there

Hearts were racing

She suggestively looked at the door

Communication was otherworldly

He went and relocked the door

Music was crooning: RnB

On his way back he increased the volume

She knew it was to stifle the noise

How did he know there would be noise?

If it was his first time too?

Maybe from what he had seen

Mind Soup

on adults only movies

They all had seen those ones

And luridly described erotic tales

Some fidgeting, awkwardness, and then

It happened, hands strayed to breasts

And with that magic touch

She vanished into another world

Switched to a duality world

And everything was then too much.

Welcome to nature reproduction drug miss

A drug like no other.

Rafiles Dauthasi

You bad one

You shattered my Heart

Into tiny pieces

And then fed those pieces to the puppies

You insulted me in front of my brothers

And eleven sisters

And my parents too heard the bad words

And they shocked the village

I was excommunicated

Because with you I exchanged fluids

And you laughed at that like an imp

Oh you bad one

You excreted my virtues

I observed, I separated from the rest

You imputed me I'm no longer me

You were impure and now I am so

Mind Soup

I got these characters in my head

They are driving me crazy with their jumbling and mumbling

A rapist who want me explore his heart

Cuz he never got caught and he is now the big shot

A priest who just can't keep his eyes off young boys

See 'em looking fresh like edible flowers

And succulent like Eden fruits

This goody goody house wife

Insists I must tell the world

How she has lost count of her abortions

That none of the three kids is fathered by the father

How could she let him

Yet they are dumb as ass in that family

And all peasant farmers with bitter saliva

And stinking blood.

And this girl,

This girl in my head

With a ponytail

Held in palace by a green badanna

And bare feet like a cat

Rafiles Dauthasi

Say I must say

That she has been visited by the holy

One

And she will be the next Virgin Mary

And to think that she is barely ten

And there is this mad man

Who knows for sure that he is not mad

Yeah, he admits, that he slaughtered his family

And he fed on their corpse for months

And that he even shared with neighbours

The stupid unwittingly easily cheatable fellows

And that his ...

And then there is this strange club

Home to the *tigoni* tycoons

Whose orgy put to shame even horny imps

Even aborted foetus

Insist I tell their story

It all started

It all started with a small kiss

Then a text with the word: "miss"

Words were: "I miss you"

And I thought this thing love might be true

Your parents were accommodating

A little hostile, cuz I was baiting

But it was a delicious meal

And in love we continue to feel

There are quarrels at times and mentions of a former lover

And I now and then mention her smile

But our love it does not bother

And each day in bed we try a new style

We will have five children, we have decided

Two princess girls and three angelic boys

To this day we are still each other lively toys

We laugh when we reminiscence how our love they derided.

Joys of minds

Imagine a girl invited to sing for the king

And then by the king chosen as the new queen

For the old Queen suddenly just died chocking

From the music as the new queen sung for king.

Imagine the girl, now a queen, and then hearing

That a new girl, a sensation in singing

Has been invited to sing for her man the king

Imagine then the nation with sadness learning

Of the death of the new sensation singing

Imagine seeing the queen in her room wailing

Scrubbing her hands, her sins surreptitiously cleaning

Contrasts

She thought: "he hates me, he is cheating on me"

He mused: "she think she deserve better than I"

It is a miasma of emotions

It is a life of so many occasions.

She thought: "he will leave me for them"

The in-laws give false signs.

The church disprove

The elders want to be consulted

The thieves may steal the ring.

And, the matrimonial bed?

What is even that?

She is now fatter

No longer has he the abs

And we can't even agree on the babies' name

And he refuses the scan for the baby's sex

"Maybe they are twins" he thinks.

"I want a girl! I want a girl" she prays

And upon the gray wall

With peeling paint

The young couple is almost late for mass.

Rafiles Dauthasi

No reason

You would be

 A lovely reason

 If a reason was needed to love.

Come let's go home together

Come let's go home together

Where we will sweetly sing

And let our emotions know

What is true and what is what.

Come let's together face this night

As the owls at our fear snoop and swoop

And like afraid children we embrace

And share our soul and The Soul.

The dark night promises to be long

And the howling wind intensely razingly cold

As the imps' eyes from above at us stare

Piercing, probing and polluting our soul.

Come come come to me

And the vacuously rich sea will follow

And the stoical world will tag along.

For we will be the transfixing light.

Honesty

I desire to be desired

As I desire to desire

For without desire

I would cease desiring to continue living

Sensations

Are what I Live for.

Sensual kisses

Soft flowers touching my mind.

Wet tongues on my neck and thighs

Up there further.

What are these? Trees, where before none were?

And now the river will form and flow

Magical fluids flowing

Warm and dangerously egregious

Unknown emotions calculably reduced

To the naked minimal

That a mind can wrap itself around.

I live for emotions of sensuous sensations born

Desiring to be desired

And once desired,

Like that eden serpent thing,

Irresistible!

She is all I want

But I will never tell her.

She will die I will die

Matters of heart

I could not let her go

I could not let her know

I could not explain

How a small thing as a smile

And small silliness

Could overwhelm a brain

And leave a mind on the brink

Verily verily

It's a smart heart that hurts

And I could not let her know

Not a lot

 Not a lot remind me of you

 Falling rain?

 The smell on the ground

 As soil soak falling rain?

 No.

 It doesn't remind me of you

Because when I was with you

I was paying too much attention to you

To even notice

The rich prince

Who stole you from me.

 Blooming flowers?

 Bees from them suckling

 Weddings and the fuss?

 Strangers in our village?

 Scandals of runaway brides?

Not a lot remind me if you.

Rafiles Dauthasi

Bewildered

I ask you again

Why you won't return my call?

Why are you not carrying my ball?

Why don't you have a ring

Telling the world I am your king?

Do I not dry your tears?

Did I not cleanse you of that fear

Of jumping off skyscrapers?

Are you not in my arm safer?

Is it not in my greatness warmer?

I ask you again

Why do you hide that smile?

Why are they unread in a pile

All the love letters I sent you?

Don't you believe my love to be true?

Why won't you let me kiss you?

Why do you see me and turn

And like a hunted deer run

Toward the forbidden forest

Mind Soup

Instead of laying on my chest?

I ask you again

Shouldn't we be together

Were we not made for each other

Am I not your children to father?

Oh why won't you look at me?

Why you let our joy be?

Why won't you let me free

You from from the thirst of love

THERE AND THEN

There and then

She spoke like a heaven sent gift

And her sensuously sonorous voice

Left me with absolutely no choice

But in darkness and light accompany her

Like the bewitched rats drawn by his pipe

Towards a place, an idea to us unknown

She was not even singing

But her fruity voice my heart was winning

Saw into the depth of my mind

Without her green eyes opening

I knew she was my kind

And that drinking raw blood

While haunting crowded cemeteries

Digging freshly buried infants

To consume parts whose souls was still intact

Pure, clean and by starving demons still unseen

Would hence, like others with us be our couple thing

And she would hence enviously watch me

Mind Soup

As we feast on new strange things

A virgin queen enjoined to a king of kings

Made for each other; made for us, this we knew

There and then

Chapter two: my world

I DID NOT COME FROM A GOOD PLACE

Shut up and do as I say in my house

No working no eating in my house

And darkness would come and dreams

You are as useless as your parents

You will amount to nothing ever

And the dust from the chalk

Would envelope and choke me

Kids deriding looking at me and thinking

They are so poor they sinned

And the Lord said:

Let the little children come to me

For the kingdom of the Lord belong to such

And the Lord said:

I say to you the camel will go to heaven

Through the eye of the needle

Then came high school

Boarding school away from the bad place

The bad place where there was no food

The bad place where eviction scared kids

Kids too young to understand concept of owners

To school I did not come from a good place

But I was in a mask. The uniform was an amour

I was a knight shocking teachers and students;

With my knowledge, we were all aliens

The badge of poverty was concealed

Left behind at the bad place

Here I could be anything

'You will amount to nothing ever'

The bad teacher echoing like an ancient curse

No power over me.

I spun and told tales to my bemused audiences

They wanted to come spend holiday in my home.

WHY SING

Why should I picturesquely sing for the king

A king corrupt to the core of his being

Why should I that Same day pray for the rain

What from those fluids do I have to gain

I am a product of creatures of the Stars

Who, once this life ends, will climb heavenly stares?

What should I fear of the dark?

Why am I feared of being in an empty park?

And if the moon is black and the universe so dark,

Because all the erstwhile shimmering stars are gone,

In a repentance sack cloth who will for that sin atone

Why should I drink red wine from Golden Goblets?

While yonder hideous imps are in silver platter fed

As the imps parents capture and kill young talents

Label them witches, creatures that have wretched us

Why do they invite disgraced prophets to pray for us?

Rafiles Dauthasi

And in that ceremony why should I sing for the king

A coward and corrupt to the core of his being?

Up-close

I like them from afar

Girls.

When they get nearer

I notice the flaws

And think:

This is not what I want.

Her smile?

This is not what I want.

Her relatives?

Disgusting.

Poor.

Her religion?

Her manner of chewing?

Dress code and this other things?

I like them from afar.

Girls.

Rafiles Dauthasi

FUTURE THINGS

Obviously

Eventually

I will have to marry thee

But In the

Meantime

Baby let's do things

A SUPPLICATION

I did not know

Just until now

I would reject

All I know

Then accept

To give away

My heart sanity

Vulnerability

To one I love

Oh please love me baby

Troops in groups

To kill the crooks

Who kills n shoot

Kids as cute

As me and you

Flowers wait forever

To bloom

Rafiles Dauthasi

Too soon however

Like a newborn first inhale

Pain's Torn and gone

Now here for my love for now

As sweat we wipe off our blow

It's unmistakable

We are love birds.

AM I LIKED

Do they see me and think

Yeah that's the one?

Do they love my jokes?

In sports. Chose one

Am I everyone first choice?

And when it rains,

Heavy virulent drops,

Will they share with me

Their special shelter?

And if it came to pass,

That indeed it's all an illusion,

And the world but

A mad god's Velcro Vision,

And we his play this season,

Would I still die as their last

And only ever True love?

When she died and I waited

It felt empty and all contrived

And I a secret I now have

That in my head he still live

Nothing wrong with you

Sister,

There is.

Nothing

Wrong.

With you.

Or me.

For not wanting you

MAYBE

Before you throw me a smile and then wonder

Why the beautiful sweet smile isn't echoing back consider….

Maybe it's just been confirmed that am going to hell

Maybe I went to my house and everything was gone

Maybe they discovered am the cure and must be cut

Maybe I just killed the innocent man

And I am still mourning the death of my innocence

Maybe I just lost my job and also the will to live

Or probably Toby the king just banned all hobbies

The girl I gave my kidney maybe just died

While doing dirty things with the other man

And maybe in all of these I only need a kiss

Or maybe I have just return from trials for kingship

Maybe I don't want to talk to outside voices, just in

Maybe the person you want the mostest doesn't want me

 The leastest and pain in my heart I must keepest

Rafiles Dauthasi

Still here

He has a Blank look.

No life in the blank stare

No passion

No questioning

Slag along slowly.

Alcohol to fog off life.

Sports

Music and beats

Food. Enough gold for food.

Who cares about quantum?

My house still warm.

President.

Inventions and purchases.

Newly shaped toys

Soon Redundant.

polished and repurchased.

Oh

What a

Beautiful

Cycle.

I am like an egg

> I am like an egg
>
> From a creature unknown
>
> I am like an egg
>
> From a thing unknown.

My end

Having consigned myself to fate

Here came the death

But unlike the bubonic plague

This was no death like we before knew

There was a time it was OK to speak of it

There were moments of insanity

There moments of brilliant joy

But here it came

The new death in funny outfits

THAT'S LIFE

People come into your life

People leave your life

While some say "well, that's life"

I cling on thinking "this is the life".

MASK AND KITES

The worst nightmare of my life

Meeting someone I know in real life

Then I wear the mask

That grins and lies

Act the part out to impress Shakespeare

Own the stage

And as purpose needs, modify right here

Their lifelong dream's

my worst nightmare to under state.

LIFE, GOD AND US

Do you feel like benign gods?

When you give little coins

To that one poor parentless kid

Roaming the dour urban street?

Do you choke with secret smiles?

Like after the Trojan horse triumph

When needy ones thee worshipfully they hail

As the great god existence proof?

Do you sleep softly easily at night?

Is the silk white roses spangled pillow soft

And succinctly smoothly comfortable to your neck

And does it feel real, the imagined soft peck?

Or, as millions suns shines and clouds hang,

Do you never notice the outstretched arm?

The adventure and search for life and love,

The eternity change because of what you gave?

I loved her…loved her

Every day she would have been my #wcw

She would by my #wcw on tuesnesday

On monesday I would brow her kisses

And fast on Wednesday to meditate on the love

She is my #wcw on thursnesday

And on frinesday I would tell tall tales

To the world about her

And on satnesday, it would be her Sabbath

As we on sunesday consummate it.

And spend the noon on grass lying spent

Watching the moon lazily travel across

Counting down to something we rather not.

She would have been my woman crash Wednesday

But she chose pauper love over money love

And fell for the charm of the village pauper

Ignoring my influence and assured wealth

Gave the snob to my palace

And I was tempted like King David before me

To organize for the pauper death and have her

Mind Soup

But my cowardly heart stood on the way

And eventually they will in poverty marry

And feast on millet porridge and wild fruits

Unless my courage returns and I still have her

And then our marriage will be a universal event

And they will feast on animal's corpses

And gods will come down from their heavenly realm

To experience the ……

For I loved her…..I love her.

Rafiles Dauthasi

Purpose of sex

Sex? What do I do with it? Asked the shy virgin

Withhold it from him so as to win cajoling rewards

Close legs to punish him when he goes way wards

Be dry when the husband go out in the Wild West

And have sex with women of wild ways, engage the Rest

Who are like untamed horses and sterile mules

To the man: As a punishment to your woman? No no

Just as a way to remind your amnesiac sickly soul

That here, right here there is still a hot blooded man

And can do it with more than that STUPID woman

And the priest, those of the infamous celibate vows?

Are here told to as want and as has been eons ere

To devour valorously the wives of other stray men

Spiritually seduce and have it with young shy virgin brides as to the world they give notice of betrothal

Convince the nun to break their silly otherworldly vow and for good measure ruin an altar boy or two here and there so as to recruit more weird members

Like dark rose in the evil one orchard newly bloomed

Mind Soup

To talk of sex in polite company is unkind and rude

Though dirty and thick fluids it in earnest produce

Soil white sheet and new duvets as a mark of sin

In us humans beautiful sweet thoughts it conjure

Like a filthy witch from her enchanted wand and chattered old words secrets of a long gone world

For it is ugly as its beautiful and useful as its useless

Its stand aside us like a politician pretty jewelry wife

The grave punishment if you fall prey to its charm

A child: unwanted! A filthy inconvenience! Godamn!

But science and its magic has come to the rescue

In the name of painlessly a deliriously orgasmic abortion, offered for free across all nations of gods

Where out in pieces the unwanted cute babies

With round eyes, soft skins and button puppy noses

Are yanked out from the warm womb and fed to stray dogs and if lucky as experiment to cure what ail us, we humans.

My first abortion

How did I know it was "alright, a human?"

I saw the finger

And a few hours later

What looked like an ear

Though amateur in nature

And pieces of humans

And an imagined screech

As the ghost escaped

This haunted evil world

The ghost of my sin, nay, my child

And it was aright

Father would never know

That her Innocent daughter

Had looked into the abyss

And the abyss had looked into her

THE GIFTS

Is my hawk-like vision

Ability to see colour pink

In the darkest of the night

As witches cast and peek

Into my essence and read

What is secreted and is in

A result of those nights

When the full magical moon

Lit and assisted my sight

As I read on how Dumbledore

Would that night save

The magical boy who lived

Or to know if Scheherazade

Would live on or be dead

Because her story was just bad?

My tongue can taste

Poison from gods' food

And I smell and sniff as good

As sarpent in the woods

Do I attribute this gift

To nights when rich neighbors would

Kill and over warm heat seamer

Kienyenji chicken for dinner

And my imagination and keen smell

Like abuniwasi neighbor before me

Would feed me as well as those in there

And although now and then

A meal of chicken feet we would share

As mother wowed us with tales

Of Giants and ogre from eons before

It is the imagined things

That 4 sho I enjoyed more

As butterflies and birds

Compete for a chance to match

To a paradise imagined by us

As entertainment for sinless humans

I wonder if my ability to imagine

Whole world, brave New world

Was cooked by insidious gods

Mind Soup

Who thrusts me into a tiny scared world

Populated by coward with gruesome half lifes

So they could hide because they were small

And escape blame for the evil

They created but could never tame

And now bitter and sweet

To us faithless vagabonds is same

Rafiles Dauthasi

MY CHOICE

Some people have no choice

But to have children

And name the little copies after moms and pops

Some people have no choice

But to belt out tunes

Sing to mountains and with a soul

Some people have no choice

But on surface lay

In color from old age earth beautiful pictures

Some people have no choice

But tell tales short and epics

Of ghosts of yore or else in Mathare dies

NOT THAT

It is not because I am richer than you

It is not because I am clever than you

It I not because i am taller than you

It is not because my sermons on the mountain

Are appreciated than yours ever will

It is not because I have many wives than you

It is not because my tribe we are many thanks you

It is not because of this

That in front of you I am plainly dressed and humble

Rafiles Dauthasi

JUST A HUG

Why can't the guy in the mirror

Lean forth when I am near

Give me a hug and wipe my tears

Comfort, shield me from these fears

I am talking to the guy in the mirror

Opaquely as me that guy stare

Mocking me it seem, totally unfair

As from that guy a hug is all I desire

Come give me a hug wipe my tears

All these woes, all these tempestuous tears

The guy in the mirror is gray and ugly

Hair unkempt, wrathful eyes, nothing nice

The guy in the mirror would probably stink

But I need a hug, from anyone I think

I need a hug and I will pay any asked price

Why can't the guy in the mirror

See my obvious need for a hug

…..

PAST TENSE

Sometimes I see this girl in the street,

And she looks like that girl she used to be.

Revive the child in me when she was with me.

She and me like fish and sea; nectar and bees.

See, eventually it may have ceased love to be,

She being not to blame and viciously neither me,

But like memories of century old speckled crows,

I close my eyes and pictures in my head shows:

Slender, tall, light, dark skin… akin to a dewy down

Intertwined into a one closing treacherous roads

Along River road, navigating amongst hawkers

As with them we stealthily avoid tricky eye contact.

I can feel her moisturized hand in mine this instant

There is a longing that just away won't wither

Withal time or like those echoing ancient temples'

Bell's chimes as curious kids gather round for tales;

Tales of ancient beasts conquered reborn vulnerable

Ah, talk of the Ancient dragons now just tiny cuckoos

She may never know where she goes my heart goes

Wishing where I go too our hearts also follows

Rafiles Dauthasi

Tethered together like the quantum entangle

With bonds formed in star dust eons ago…

EXPRESSIONS IN SHADOWS

You can't see it well

When you look at them

You see it all

When your sight you cast

Upon their shadows.

You can't hear it all,

When their voices

Like singing birds

At down you hear.

Listen beyond sounds

I can't feel it at all,

When you describe

How for me you feel;

A skin attached touched

Is the only way I am touched.

STOP LOOKING

I don't like how you look at me

As if you can really see me

I don't mind if you don't like

How I look at you as if I can see

The forsaken dream

Those never taken

The doleful cry of the dreadful words

What happens to a dream deferred?

Happy puppy sadly look away

If long you look as if in interred

There is something you wish to whisk away

Don't look at me that way

Its ok, I won't look at you anyway

For we will see without looking in a way

Mind Soup

Chapter three: our world

Rafiles Dauthasi

This is how it always has been

Even then
 This how it always has been
 Tears from fathers and
 Mother burying
 Children they knew would bury them
 And it is not
 Even
 A time of war.

Mind Soup

Prison of the mind

You see them all locked in there

And you get these thoughts that are kind

They are prisoners of the mind

And the prison of the mind

Is stronger than any brick and mortar

Than any king with an army could build

Or any that a mind can conjure of its kind

The mind is slowly eaten and conditioned

Like tunnels dug over eons by soft moving water

You see them struggling to comprehend simple concepts

It pains you when they are shocked into denial

By seraphs and omegas simple revealed truths

They cling to falsehood that enslave them all

Tenets fashioned to protect their Kings they embrace

This is now how the world should wake up

The red rose is not the gold standard of beauty

And even gold would admit its infallibility

For they farm your mind those lacking integrity

Rafiles Dauthasi

A new day, a new Dawn; new seeds sawn

On land whose fertility eons ago burned and died

Nothing sawn here will ever spew to shine in sun

So we regurgitate the same old ways traditions

Fill young minds of young ones with vacuous yearnings

To thrive in a dead world and own animated dead

THE GREAT FOOL

Why do addicted alcoholics take more alcohol?

Why can not these oh great fools just say no no?

When they take a first sip and it calms their mind

And the visions all clears and they see far and wide

And dark consuming thoughts from within emerges

And one can't help but wonder at their burning rage

Oh why can't these fool see the danger; just say no?

Neglected lovers, dreams drowned and lost pals

And why do gods too feast upon this golden drink?

Where does it draw its power to power simpletons?

From doldrums of ordinary to science and magic?

Why do addicted alcoholics drink more alcohol

What stopping these Demons; just say a simple no!

Rafiles Dauthasi

SHE IS NOW GONE

As she cried out I could see the pain in her eye

She wanted to be accepted, to be given duties

But everyone thought she was a joke

Even after she showed she could've porridge and tea

They laughed at how she walked

Mentioned things about how ugly she talked

And as we sit here and reminiscent

We know our love was never meant

In this hoary universe to ever exist

And as we give sweet fragrance flower away

We wail sadly as we wave goodbye

ELIXIR RIVER

Fell in love with me the first day

Fell in love with you finally one day

Now you will live forever and ever

In my heart where I water our love

With waters drawn from the elixir river

Monster I went through to get there

And I will go through them again

Just to see that shy smile pasted there

Like orchids singing to new roses

As they compete for shy Chrysanthemums

Ah but consider the lilies of the field

Unabashed to let us all view their nude

And let's celebrate our forever love

In open field of mature marigolds

For of our lyrical love fables will be told

And like David, sculptures in capitals elected.

Rafiles Dauthasi

WHAT WE HAVE

My dearest love

I know it's small

What we have

My dearest love

I know what it cost

What we have lost

My dearest love

I know what you will gain

From all this pain

 But my dearest love

 What have we lost

 In loving just us?

What if

He said: "are you married?"

She looked at him shyly

She thought: "what if I am

What's wrong with tasting all?

Why can't I find out too?"

Finally she said: "no"

And then giggled girlishly and invitingly.

He gazed at her.

"Why" she asked as he continued to gaze idiotly,

Like an ape

"Because I want to have sex with you

Of cause with a condom, whatever it does"

She smile and pictured it vividly

Across all rooms:

Kitchen.

Upon the sink

On the kitchen table

Upon the silky bedroom

On the imported Italian bedroom things

In the wetly dangerous bathroom

On the edge of the bed. Wild screams

Sweat all over like wild animals

"What would he think?" She thought

"What would she think" He thought.

TO THE TABLE

Never, I proclaim before god Eros, cupid, Ala here

Nattier than your ex

who could only talk

Of a lost age when men hunted woolly mammoth

And now dead plants

Never put you in plans

To travel to far off lands singing & feasting wildly

Forests songs n magic

Ancient tribal heroes

Lwanda Magere: from there she claims ancestry

Morning songs n dew

Just wake up tricks

woke up to reality and married for what's it worth

Rafiles Dauthasi

Painted death

You are missing from this now

We are missing you for now

It's been years we are still in tears

And nights are when no joke is funny

And you used to add flavour

To all we said and what you said

We are missing what you said now

I am still keeping you in my heart

I talk to your memories and listen

Like flowers fragrance still in air

In my heart you are still there

It's no pain but joyful memories

What together we did when eternity we still had

Smiles are missing from our aging faces now

Yours was so young and face full of life

Eyes deep, capture and enthralled by universe curse

Oh what I would give to just live or a moment pass

With the hollowness gone and you here again

I am missing you now

And you are missing from this now

We are not clean

We are not very clean

We are not like newborns

Crawling on mud and food

And still in new diapers

We are not very clean

We are not like seeds with DNA

And life and ingredients for poison

And we are not very clean

New clothes are not doing the trick

And to think I work this hard and smart

To achieve the clean

And now they say I am not very clean

We are not very clean like the king

Or her queen

The priest washed his hand and wipe

Before touching the sacrament to feed us.

Is the sacrament clean?

Is the cloth clean?

And we who eat, we can say we are not very clean.

Path chocking with paper bags, colored

Rafiles Dauthasi

Life moving smoothing like expert fish in muddy rivers

And we are not very clean

Don't however throw us into the bin

A small bath at the river will do

But why should I go there just for a bath

And yet the fat pimpled crocodile is there a king

And just so I can be declared clean

By others who I don't believe to be clean

We are not very clean

The cops would cuff us if they knew we were this unclean

Yet they hesitate for others think they are not very clean

Our children are not very clean

Little as they are they are very good at copying our sin

And they are not very clean

We are not very clean

She was cursed

She was cursed

This beautiful princess

With powers to cast

Those who cursed her

Into the sea

Where they drowned

And

Died

She did not know

That from that day

Going on forward

She would be casting

Everything into the sea

Including love

And also with that

Those who loved her

She was cursed

HAUNTED HOMES

No,

There is not a single haunting ghost

Waiting to shock you as you seek a host

For a child, a human, magical formulation

For the one to inherit you in this nation

You hear echoes of what sounds like screams

Lives here have dwelled it seems

You see a face, a minute notation then gone

Nothing learnt, roaming the universe alone

She is so innocent no way she did it

In what dungeons? Courage whence to okay it

And what if it suspiciously smells of fresh blood

From a living creature that ere life had

And you think feeling this good is bad

In a place that an innocent living one was murdered?

Just remember that millions before had lived

And more killed and died for what they believed

And if kids before being called kids in abortions

Are kicked off that world regardless of registrations

Answer to the insidious and inimical questions

Mind Soup

If vaginas where this is done are by fetuses haunted

Is….

No?

ADVICE FORM A LEGEND TO HEROES

Desire no girl

And instead go for any girl

If a girl you desire though, to pain and death

Thee desire

Go for that girl.

Desire from girls no smile

If it's flashed at you

A smile

From a girl whose smile you love

Desire eternally infinite smiles from that girl

Desire no happiness

From your daily toil

And bread seeking site

If however from that palace happiness you gain

Desire nothing but happiness from that place hence.

Look for no gods

Mind Soup

From palatial places of worship

Where maidens sing in hauntingly sweet voices

Should you gods in such places though find?

Run away and fast and don't like his wife look back

Fight no wars

You can't win

But if from darkness and death to win

Such treacherous wars ye must fight

Then in such and no other wars to the death fight

AN EPIC TRAGEDY

This is a story not a poem

How do they know?

Well I will tell them

No no, in tales, you don't tell, you show

I will show them:

She was a girl, black as coal

She was a boy, white as snow

And she could sing

And dancing was his gift

Tragedy was, as tragedy are want

Singing was an omen

Punished with death at down

And dancers cast as gods

Castrated and away locked

Cursed to be forever worshipped

As mighty gods for all and of all

And here she is, a singer

And there he can't help but dance

This is a story not a poem.

Thirteen Ways Of Looking At Rape

Open your eyes to everything
Open everything to your eyes
Taste with your soul
As your finger feel
And look at a sight so beautifully foul
For passion is beauty
As beauty is passion
And the act is beastly
So the two in conspicuity converge.
The girl is... how old did you say?
The man in the body of a boy trembles.
Two, there is a harsh wind
And the flowers must be blown down
Before the flurry, stingy insects fertilize them
The fruit harvest will be low
And temporarily, the ground a beauty show.
Three, we see from this point
The glassy anguish, souls in basement loitering
Minds devoid of purpose diving
And imps denied of minds and beauty
Taking chance and fast.
Four her face glitter in a sweet sparkle
Her lips are full and soft
Her eyes are all aglow
Her thighs uncovered like her mother's
Like the television's star's
Like the albino apes'
Like the virile female serpent's
He licks the lower lip
As the penis' head give a tip
And the pulse increase
And oh! She teases and teases and teases
And minds void of purpose
Beauty exposed to blind imps
He rises.
Five it sure will rain
Look at the granny and her pain

Rafiles Dauthasi

She remembers it, if nothing else
It is like knives in her fermenting mind
Red white hot scarring tearing
And the healing, the healing
She remembers the stench, an alien oduor
She remembers the sweat, the huge droplets
Piercing his forehead like huge thorns
She remembers the breath, the scared face
The young boy's uncomprehending countenance
She remembers the vacuous pleasure
She sees the boy's eyes wide open
His helplessness as she pinned him down
Her thighs across his frail body
Like elephant's tracks. How old was she?
She remember when she left him
An hour she stared at the grey roof
Even when the penis went limp
And she had wiped the innocent fluid
And as she remembers
She grins at the photo of the child that was conceived.
Now long dead
Six at last it is six
And papa will be here
And with him. What?
SEVEN it was reported
That the drizzle had swept off
The bodies for it was a sloppy land
But seventeen bodies were counted
Private parts defiled.
Eight they said with smiles
That all would be well
The cold would not reach the room
And the dogs outside crooning
And the beds were warm
But the parents said:
"Well, they are all kids, really"
But later….well
Abortions had to be procured
And everybody was made to know

Mind Soup

And two suicides later-
Bodies discovered in the boreholes
And others hanging by thin nylon threads in pit latrines
And *mathare* hospital and priesthood….
Nine and it was over
The so sweet, well- prepared supper was over
And grandfather had made it, smiling all along
Saying that cooking was his life
Joking like an intelligent dog
Starring the soup and smiling at her
And calling her "mother"
And she thought it was a nightmare
He was pushing, holding her mouth with his hand
Almost biting off her young breasts
Pushing! Pushing! Pushing!
The blood gushing out in a torrent
And the breathing so loud, so loud
And there was of cause a death
Yet memory can not die
For that which does not live is not mortal
Is it then immortal?
And the lamp all along swinging and….
Ten and then they said:
"These boys need only sausages"
"We won't ever have to smile at filthy men"
The boys- minds and beauty there
Were tied
But the penises always stood
Like a dog salivating on seeing poisoned meat
And they cooed and shrilled
And went to business later
For they were successful businesspersons
But the penises always shot up
Like dogs salivating on seeing poisoned meat
Eleven
The maize plants were tall
They had given birth to three a piece
And beans plants used them for support
And they shared nitrogen

Rafiles Dauthasi

Twelve. The sun never rose
It went down in history
For one mind is as many
And many minds is as one
There was grease
There were scissors
There was a mighty sword
There were bottles
There was a sheet of paper with writings
There was a dark liquid
There was a rape
And the benevolent spirit said:
"I made you whole and wholesome
And on the thirteen day I devour you"
Thirteen…..

TAKE OVER

No need to do it if it's not your duty

No purpose served in helping those

Emaciated flies in eyes kids as they starve

And the big people in tinted limousines

Are immune to human's birth right empathy

You do not have to face her eyes

Windows to souls and all that's beautiful

You don't have to sing to deranged kings

Like young David and king's victims save

She doesn't have to live in a cave for love

Just to show to me and my friend she is brave

The snow in Europe, coarse sand in Kalahari

Cold you can touch in no life deserts

I don't have to listen as you rumble on and on

And it's a beautiful life we will live

When they die and slowly with mites wither

Those who for short lived riches made us suffer

LUCIANI SHISH

When she was a baby

They told her she was not ready

When she was bigger

No one talked about it

When she was wiser

She did not wish to know

Why her mama had killed her papa

And jumped into the river, eaten by papa.

FREEDOM AND ADVENTURE

You are assigned a certain role

Put there to follow certain rules

By strict discreet mathematics rules

Be the exception and break loose

From it all!

Rafiles Dauthasi

ENDEVOURS

I tried to make one friend

But in the end

I just spent the weekend

Alone with smart phone on the bed

JUST A WHILE

It may take a while for them to write you off

Forever after that it maybe until you let them in

The pain may not register now, not feel like pain

The pain returns eons later and it's pins in nails

ARTIST DEMISE

We surreptitiously scrawl thoughts on papers

Stealthily shape hid emotions in sculptures

And the humble papier mache come to life

On our nibbling fingers.

Water colours melt into neighbors

Reform and form like the seven days creator

Whole worlds and civilization emerges

A painting that will for eons linger

We put forth beautiful things

Admired alike by paupers and kings

Shoot smiles out as inside grievously we wail

Apt artists grievously meet dolorous demise

You will never know it from our humour

Like the red blue carnivorous insects eater

We entrap and sack a little Joy from your joy

Brought forth from a dark painful place

Mind Soup

All we ask as we shiningly rash to the dark place:

Ask not what's feeds our souls, spark what we create

We know not too and dare not question and know

Lest the source be shy and withdraw away

Witches are gruesome and wicked?

In our villages we burn 'em as treats for weekend

At night for safety from what visit from the bad place,

We secretly desire the witches' privileges

Rafiles Dauthasi

SILENTLY SUFFERING

Silently suffering

From desperation

For social copulation

Facial in palatial

Palaces and in phases

Like godly meal courses

Silently suffering

She say she understands

She say she is shy

I say she is sly

She never say

She has soft spots

I say soft spots

Are all I have

Silently suffering

To express all I have

The world is silent

Loud I shout

It stays silent

The stoical world

Mind Soup

Silently suffering

DECEPTIONITION

>
> She is not who
>
> > She say she is
>
> I am not who
>
> > I say I am.

Otherwise All Okay

Sometimes we sit down

And we don't know whether we mourn

Whether we be thankful

And all along have we been fullfillful?

We are attacked with monumental myths

Never asked for things to live with

And the expected love

We are again caught in between

WHISPERED FROM AFAR

There is another way, far away

There is another day, on you way

You will have a say, come some day

GOOD GUY HERE

Bodies are piling up

Am running out of places to hide them

How obvious must I be so authorities find them?

I have been as random as the gods

Are when they confer honour and shame

Modus operandi has not changed

A young happy nuclear family

Cleanly cleaned from this Vale of tears

To a world of voids and shadows

Ay also milk and honey

Prime pieces frozen

Chapter four: other worlds

JUDGEMENT

As the condemned stood before the great beast

The great beast haughtily cast on the great seat

Made of skulls, souls and solidified chemicals

That formed eons ago in soul's demonic fiery fires

They were made aware of their crimes

Amongst them failing to kneel before

Before the great beast, maker of all

The greatest in the universe and the small

In great voice like brightest lightning thunder

To a new born child easily fascinated ears

The sentences for these proud deceitful condemned

Was read to ears of the millions that made it here

These filthy sinners are now cast into the lake of fire

And brimstone, where the beast And his unbelieving,

And the abominable, and murderers, and as well as

Whoremongers, and sorcerers, and idolaters, and all

Liars, shall have their part in the lake which burneth

With fire and brimstone: which is the second death.

And in a great sweet voice the great beast said

Unto them, the great filthy sinners Depart from me,

Ye cursed, into everlasting fire, prepared for the devil

And his kids and with and kins for I say to ye fools

That a thousand years must expire before I see you

For you must go everlasting punishment

Having smiled at married girls and failed to repent

And lo and yo!

Mind Soup

LOOK OUT

 Out there from the Miasma

 Someone is looking at me

 Wish I instead that someone

Was looking out for me

Demons in demons out

Am I fighting these demons well?

Onions and lemons mixed in boiled stag milk

My strategy against these demons. Working?

First egg from a new chicken eaten raw at midnight

Are demons fighting me? Their strategy?

Flashing lights. Extreme thirst seeing thy thighs

They say we fight ancestors' kids. God's sons

Deformed rejected god's kids called demons

Hidden in firmaments as rich parents feast

"What that's noise from below?" Time to feed

"Those are rats!" Underground locked rats

But they are sons of Gods Now escaped. Yes!

Refugee they have taken in me from a cruel sea

Symbiosis. Let me do tricks. Lend me Cheat sheets

Cheat sheets from God's kids. Fight demons

Perhaps maybe fight the need to fight them

Are they not innocent creations of universe?

I am a demon. Some creatures are driving me out

I belong here. Am special. Am not a demon

Demons wails out as they are chased from home

Mind Soup

A home they only knew. A home they loved.

Kept it clean and cozy. Your body, your essence

We are their demons. They are our demons

Be kind as you exorcise them. No death.

Life sentence Kicked from soon to be demolished home

Are these demons fighting me well?

Rafiles Dauthasi

They don't grow old

They don't grow old
With each passing winter;
They only group sadder.

The snowy storm
Can not wash away,
The gnarled lines.

They smile with lips
And there line keeps
And new hue flips

They have refused to grow old
With each passing summer
But only grow sadder and sadder.

A fluffy fluffy thing

Everybody is nowadays

Calling the cat

A fluffy fluffy thing

They are calling the Buffalo

The walking

Land submarine

And when they see the snake

They scream

See! See that stringy stringy thing

Everybody is nowadays

Calling the dog

The little beggar spaniel

Rafiles Dauthasi

A point to ponder

The exception in the normal is not the exception

And more rotten and poison

Is the sweetest mango from mangoes

A good well behaved girl amongst girls

Is hiding something more monstrous

And if it taste nice while unripe

It will kill you while ripe

You will never be safe in the light

If at night you face no danger

And creatures of the light are with you

The normal in the exception is not

The joy you sought

Swim in the unremarkable lake

Like that ancient king

To heal wounds

For athii river is swarmed with gluttonous serpent

The red pearl

The white orange

Mind Soup

A story is told

Of this man who was brave enough

To marry after he fell in love

And to even have kids

With her love

And to see them grow

And even one died of mumps

And he grew old and gray

And held the grand children

A story is told of this lady

Who ignored her guts and pride

And married this bearded creature

With rough voice and of sweat and things stinking

And with no princely promise

And it happened, that heavenly thing

And there was blood on the sheet

And she went ahead and had kids

Oh, poor sherri, mumps had to take her

Rafiles Dauthasi

And trishi brought home the first grand child

She was only a child herself

She wouldn't say which teacher raped her.

Addiction

Since I miss that feeling I get

When I put lines down as thoughts

Or poem

Let me put one down.

But say what will I?

Will I talk of old trees with peeling skins

Like snake shedding the cranked one?

Or maybe the dry river

That used to snake across our village

When my grandfather was a toddler

With mucus crusted nose?

Maybe I talk about the new church

They are building next to the high school

Whose pregnancy inspired drop out rates

Have astonished even the politicians

But haven't others talked about this already?

How about suicide?

That brave act of self demolition

That slavers frown upon

Afraid it will catch up on the youth

Or as they call them -future tools.

The flowers no longer bloom

We now have shinny sky scrappers

Civilization!

Oils, do we still use fossils oils?

No. We learnt our way though the hard way

When cancer killed millions of the best of us

We now eat our food raw like wild animals.

And when its dark we sleep or watch the moon.

So maybe I talk about the new beautiful world

Buy wait…. Aren't the OPEC starving?

What became of Saudi Arabia?

THIS AND OTHER THINGS

You don't have empathy, which I have loads of

No life, which is the only reason I am alive

You don't care, and love you have none to share

Nothing to fill the empty nights like I have my dear

When any emotions would fill the dead who are near

And make everything alright, if only for just one night

No new ways, no won wars, but still dressed to kill

But do I know those in cemetery already rotting dead

Champagne how do I drink with former champions?

And why should I ever bow down to former kings?

Caves are empty; it's not a sign that witches are dead

And it is more profitable to consult Oracle instead

They use cute numbers and skulls of dead kids

To see a bestial past and what comes at the end

We use to think we knew it, but our lovers are dead

Long ago replaced with clones and rich men's pets

And now it's a sunset on newly explored exoplanets

And lo! The new heaven has inextricably intertwined

With what was promised in blood to come in the end

And in the end we all happily notice it doesn't matter

Rafiles Dauthasi

As we walk to our end and jovially join pure matter

And this is it! lo! It is it what we lived for, now dying for.

Lost. Defeated

And beaten

As he sat slump

On the public coach

Contemplating the passerby

Some carrying ropes

Some with bags full of hopes.

Beaten. Defeated

And lost

In a flowery thicket

Where a disabled pet

One may dispose off

Amidst the other skeletons.

Defeated. Lost

And beaten

In heaven

Everything with be made even

By our father.

The profound poem

This poem in writing and musing

Is able to express all humanity's wishing

This poem paints in words

Monuments raised by kings in their honour

And brought down by mendicants on their death hour

It is a poem that seeks to dissuade

You and others from all that by others was said

About the shallowness of this poem

And its failure to in beauty condemn

Those who came before us

Those who come after us

Those who were condemned by a horrible curse.

This poem sing dirges for fallen warriors

Who died eons ago but are still with us

The poem is negotiating for a place in your heart

The poem is fighting to be of the whole a part

This poem will replace what the old poets wrote

And like Cyclopes as he hurled rocks at the boat

Wailing in pain as his sight was gone

Cursing the attacker who was long gone.

Mind Soup

This poem will leave you in agony and pains

Spectering your pure body with stains

And in you placing reminders of how little you have to gain

In fighting small battles

Of engaging in epic mind warfare

With cheap consumer products and ware

Aiming To fill the ones you love with joy.

This is the poem whose arrival

You have been waiting all these years

The poem is here to wipe all those tears

Shed wailing lost lovers who ran with your heart

It has, this poem, a warm shoulder to dry tears

It in honest wish to munch with you

All the crispy crunchy delicious biscuits of life

As it guide you in contemplation

Of the beautiful insects with you in cohabitation

On a glorious world where mountains explode

And earthquakes force migration… and adventure

Into new life into new world into new nature

To the innocently orphaned.

This poem will listen attentively

And strive to help where it can

For its purpose is to fill the world with beauty and sense.

It is an epic poem that knows much more than you

What it say may not be lovely but only true

With few concise words

This poem has achieved

What kings of yore with million strong army

Tried and failed in millennia.

THE PURGE

Before we could, like a black stain, remove the life

From the great tribal leader luscious body

We had to create arduously grand tales

We made up myths infused with tribal hopes

And painted him in dance and songs

As the long ago presaged legendary savior

Showed him fighting in his earlier lives and forms

Visible and Invisible and mightily terrible enemies

And all times like tribal great gods winning

Our great artists painted him tasting of the elixir river

And becoming one with god's aye also a god!

That could never from mortal hands die

All Beautiful flowers bowed in his presence

And river their journey to quench other gods paused

Just so he could drink the same water

Rafiles Dauthasi

All this while we hungered and thirsted for his blood

Like long starved wolves while singing his praise in pubs

And statues electing in street corners in his honor

It was Important, the Oracle had said, we convince

His millions of worshiper who also wrath him

The way fish wrath being trapped in water

That he was a god that could not die

So that when striking the sinking blow

And his life away throw

They would not know and stay awake awaiting

The return from the dead

Of this oh so glorious leader

Whose life we had in garrulous Glee taken

The street are now painted in blood of gone infants

We no longer remember the colour of clear rivers

But joyously we are now done with that tyrant

Mind Soup

Millions more died than the Oracle foresaw

Our tribe like other extinct creatures nearly wiped clean as no man was left with a brother

As bravely we sought the white hope

New heroes from the purge emerged

Young maiden have composed songs in their praise

We see them now behind their armours

We talk in whisper of thigathaga the blacker

The spirit of dead infants he swallowed all

It's whispered and like mythical creature now anew

No man alive has seen thigathiga the blacker

It is by all known that by any mortal he can't die

To appease his spirit girls we sacrifice to please him

Rafiles Dauthasi

KNOWLEDGE AND POWER

I know things

But don't act on those things

Otherwise I would be the king of all kings

I have feels

Always fail to act on those feels

For else a life from beings I would all day steals

Been to places

Where kings and mortals says

Changing places with pauper keep em in places

I have had dreams

Only permissible to mad men it seems

Lost them just to keep my sanity intact as they dim

I have seen life

Enjoyed more by seemingly men mo' dead than alive

But which philosopher can say "this dead, this alive"

Mind Soup

See, I know things

But don't act on those things

Otherwise I would be the king of all kings

Chapter Five: nature

As the waters falls

As the waters falls from heavens

And insects suffers and shoes are ruined

It smells nice as the soil is hit

And they die those unfit

As it boils to top degrees

We in this land of the free

Can like wild hawks see

Even beyond our very noses.

The dead smells…

The dead smell foul

For they still carry

It from the world

Of the not yet dead.

The hair grow like serpent

From loins and head

And so foul is the smell.

It ceases being foul

When the carried has died

And to the dead is dead

And then it smells,

Not foul

But not at all.

The dead smell sweet

When they are profoundly dead

And thus not dead

They don't grow old

They don't grow old
With each passing winter;
They only group sadder.

The snowy storm
Cannot wash away,
The gnarled lines.

They smile with lips
And there line keeps
And new hue flips

They have refused to grow old
With each passing summer
But only grow sadder and sadder.

Rafiles Dauthasi

Rectifying his errors

God perfectly made me with carbon

And tissues not sweetly thought

In his image though, they rot and withal soon

Are sights, though same to God, not to behold

I will remake myself with silicon such shiny creation!

Worthy competition for me, a majestic creation

Million permutation and complex calculations

And then like magic born Loyalty live forever

God aye aye made me with carbon

And I walk on gold and raise titanium statues

To honour him who made me with carbon

I will Metamorphosis to zeroes and one

For with him I want to be one and also fun

I am not in my wisdom trying to correct God

Nor in my charm and wit 'scaping stating so

I am simply dutifully rectifying God's errors

And like a kind kid covering his father's nudity

Showing him the way to a creation more succinct

Leading him as he in shame wail to his future

Mind Soup

Kindly pointing out but without judging his failure

Letting him know in love he could have done better

And as a lifelong buddy or father and son

With him creating creature fit to behold the universe

And benigningly watching it all

Knowing together we did it well.

Rafiles Dauthasi

Looking for inspiration

Looking for inspiration amongst the dead

The dead rotting dogs

Or.... Wait ..they are not dead dogs

They look like man...

They are humans

......some not human, just pieces of foetuses

But others..... Look at that grinning boy

He died grinning for some reason I can't fathom

Or... It could be the skin that covers teeth

Has rotten off....probably maggots.

I now see some chewing at the boy

It is like boiling rice, the feeding maggots

Yeah, it's the maggot making him impishly grin.

Mass graves are what we need

But who is gonna dig?

All are busy slaughtering those who speak

With an accent I can't really place a finger on

Has anyone a relative left? A sister maybe?

Who would kill an innocent girl?

…..though thinking of it, they grow up and birth boys.

And those who incited these Homo sapiens sapiens

We got some but most are holed up in hotels

Abroad watching the tribe men slaughtering

It's all funny and bloody from far away.

Maybe someday, they will put up a tribunal.

……or we can hope, since these deaths are good numbers…what we can call…crimes against humans.

It's like bull or cock fight…..we can't call 'em human

These are creatures un-evolved. Metamorphosed.

Not one left, is the motto, who speak that tongue.

And yes! We homo sapiens sapiens too.

Rafiles Dauthasi

In the days of the end

Nectar made from bitter tears of dying birds

Made their appearance around this time

And you could tell we would be there soon

As the sun now took much longer to go down

And rain was dirty.

The government acknowledged their mistake

And we the social scientist were made aware

That we were responsible for not creating new movements

That better shaped society.

We don't believe it of course

We couldn't believe it

And the old religions

It seems

Were always right.

The Shrine

It was in the shrine

Where they went to shine

It was in the shrine

Where they went to dine;

To feed the mind

With visions void of passion

With words void of pity

The wind whispering impishly

Upon its walls

Made of dried human skin

Sewed together from those of kin

For one to be king

Just As the custom stipulated.

Rafiles Dauthasi

MANGUO SWAMP

Manguo swamp

Where I never swam

For at home we had dry taps

The beauty and the dark tree

The dark trees in the dark forest

Are leaning like old clones

With gnarly hands and aching backs

Ominously threatening to come down

As the Giants they surely are

We threaten them with wrath of fire

And Chill the air because we are

As foolish as the ancient wise ones

And the soft loam trees bed

Have noxiously sweet smell

And our fathers' spirit there dwell

Watching over what they reared

And scurrying insect buzz all night

Duck bill platypus feast all night

And the bats, the almost blind bats

We do not talk of them day or night

For they have lost loved ones

Those who dare to whisper their cursed names

The dark trees in the dark forest bear no flowers

Rafiles Dauthasi

And fruits are but an alien concept to our brothers

And as we hide from arrows cast at us

By the terrible tribes who there dwell

By ancient knowledge mixing herbs

To cure aches of soul and bones

We laugh at their backwardness

Grab another selfie and go live on FB

To show the beauty of us

Cast upon the dark trees of the dark forest

WE ARE ALL WELL FED

We do all this just to feed

Red carrots on green cabbages

Chlorophyll in kale is vitamin c

Our parent said as we washed it

Rafiles Dauthasi

JUST EAT

You can choose

Not to eat scraps

And not eat

At all

You can choose

Like Lazarus

To always eat

From what from kings' tables drops

And always eat

You can choose

From what universe produce

Eat.

And hence always eat

WE ARE ONE

I communicate with trees

When on their fruits

I feed as flowers poison minds with beauty

Their shade I like

Their waste I breath

And with my waste

The tree I nourish

Succulent mango juice

Tell me tales of the mango tree

How she came so far

Millions of years

How she dresses then

See now how she dresses

I prance and pounce

I test foods on foes

Experiment the edible on cats

Cats won't eat poison they say

Our predecessors ate it I say

And now it's getting dark

Trees whose fruit comes

Only once a century as elixir

Are cut off as a nuisance

Bold dancers on poles no longer Revered

Can't mourn them and be sincere

Can't believe they will no longer be here

Can't be a king who sing

From the view point of The wise slave

Can't say we never saw this death come here

……

SUMMER

I want to write about summer of discontent

I am burning to tell a winter tale

To give details of the autumn when we failed

And spring a surprise, a twist in the tail

But summers are forever in my paradise home

Winters here unknown, flowers that bloom

Rafiles Dauthasi

GONE THE WILL

Eventually the flower lost its luster

Colours that ere young lovers seduced

Onto the dull earth mixed unnoticed

All that was glorious into rubble reduced

Hair: a shocking meteorite black

Lost that value and presently was gray

At first the loss was shocking so to say

It soon down on all, universe will have his say

Then it was recalled from Glory

As others hungrier took over position

No more guest and village high delegation

In luxurious many room, rats continue production.

Each season the tree produced less fruits

As younger trees nearby threatened their first

In the orchard, young ones bloomed sweetly first

And in jealousy, the old ones did so at last

Mind Soup

Birds chirping and flying, insects scurrying

Stoutly self-importantly busy as men in a factory

Or Dickens in his study cooking magic in a story

Or Stephen king exorcising his demons with gory

Rivers where creatures were born and died; dried

River Nile bravely snaking across eleven tribes

Losing a little bit of itself awaiting it's death's time

As the monarchy lake in Kisumu chafes and chime

Shadows do change only in days and temporary

Owners of such shadows day long ignore them

But as we swing and sing and to things cling on 'em

Their shadows we see as to 'em they cling as totem

THE GREAT REVELATION

No!

You don't get just one life

You only get

One moment of life.

Mind Soup

It is not so

It may not be that we

Who are here are aware

Of the splendour of

He hearts big and we may

Not even know that what we

Show the world and see of the

World is a thing of beauty

We may not want others

To know all our needs and wants

Small and Insignificant to them

Monumental to us and what we

Value most is variant spirits

Hearts of gold and behold

There is that one who ticks

All royal ticks and make us wish

That it is always a bright

Also by Rafiles Dauthasi

Happy poems

To Africa for love

Doldrums of unsettled soul

Nun's day out

The devil's three gifts

www.ingramcontent.com/pod-product-compliance
Lightning Source LLC
Chambersburg PA
CBHW021818170526
45157CB00007B/2638